Slumgullion

william frank

Copyright © 2019 by William Frank
for Tuckford Bunny Press, a Private Press

TUCKFORD BUNNY PRESS

All rights reserved. Except as permitted under the U.S. Copyright Act of 1976, no part of this publication may be reproduced, distributed or transmitted in any form or by any means, or stored in a database or retrieval system, without the prior written permission of the author.

ISBN 9781798482711

Printed in the United States of America.

Acknowledgements

Cover photo taken by the author in an alley in Rome.

Floral designs on the Title page are used from the Permission-Free Designs in the book Art Nouveau Motifs, Dover Publications, Inc, Mineola, NY, 2002.

The Grotesques that appear in the *Note from the Underworld* that prefaces the poem and forms the pendant on the necklace in *Lily Totenkopf's Advertisement* used from the Permission-Free Designs in the book Mythological & Fantastic Creatures, Dover Publications, Inc, Mineola, NY, 2002.

Lily Totenkopf's Advertisement was created by the author using a whole lot of spectacular ingenuity and a magic marker.

Other books by William Frank:

The Purgatory Elm (2018)
Yuneko (2015)
Fiasco Galante (2014)
The Encolpia (2011)
The Morphine Fawn (2009)

All Tuckford Bunny books are available at Amazon.com and other retailers.

About Tuckford Bunny Press
Tuckford Bunny Press is a private, make-believe endeavor that publishes the literary works of William Frank through KDP, a great service for independent publishers. It is the only make-believe Press that will publish such funny-headed little books.

A Note About the Otters in this Book
There aren't any. Mustelids for the most part are the cutest animals in the civilized world which makes them mentally ill and completely unreliable when it comes to character work, even in minor roles. Any contributions, slight as they were, from our earliest abortive attempts at collaboration have been completely removed from this book and any purported likeness to their depraved, idiotic antics is nothing more than a masturbatory delusion. This author notes, with some sadness, that while he would still fuck an otter against a bathroom wall, he could never work with one again after such a disappointing and unprofessional cock-up. And upon further reflection, I must acknowledge that it is this sadness, and this sadness only, that constitutes their peripheral contribution to the poem.

From the Ulterior Offices of Demonic Integrity
d/b/a
Felicitous Beginnings, LLC

Vermilibarca, *Grand Mal* Mort Wentchwidge, Esq.
Bert Topside, Esq. *of Counsel*

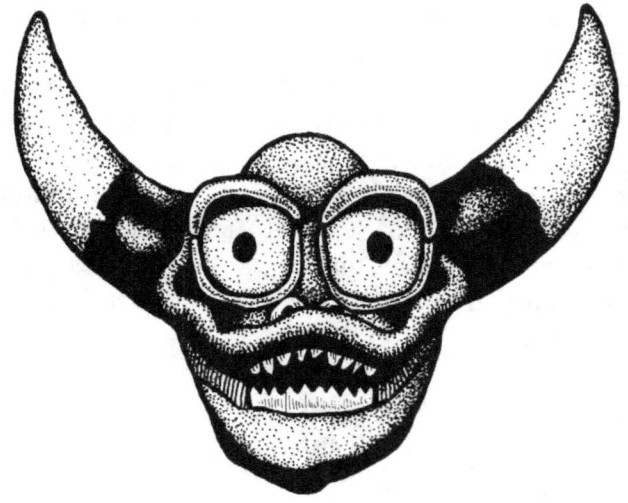

Felicitous Beginnings. At last, a group of assholes you can trust. ™

It's with great irritation and offense that we have had to use both legal remedies and persistent Black Magic to append to all copies of this idiotic book, as the books are created, a note of protest and complaint against the unconscionable smear job contained herein. Satanic belief in the supremacy of the individual should not be reduced to an overheated gangbang and we object to the accusation, implied by the agent of representation so loosely drawn in this poem, that we are nothing more than a scathefire of psychopathic corrumpers whose only aim is to tear off someone's asshole while working toward a person's eternal ruin. While it's true that we're not especial

friends to people, we have always been popular with them, providing mankind with their most delectable pleasures and fantasies while also giving boundless expression to all of their ambitions. As we are, and have been, the most solicitous Promethean teachers, we must insist it is certainly *not,* as portrayed here, just an *ass-and-cash* program; and if we expect a fair recompense for the extraordinary delights we provide, we are not unique, nor can any reasonable person argue with the basic principles of trade. The value-added services that we generously include for free are often lost on people who only consider the cost of our luxury packages. If one or two of our programs in the distant past went wrong, that is to be expected when fulfilling the expansive desires of such complicated creatures. If traditional sources have downplayed our successes, that does not give this author the license to cheapen our mission so meretriciously. And if we haven't always disclosed all of the consequences of a program, it is invariably because they are so obvious as to be too insulting to mention to anyone created with an intellect. Coffee may be hot.

We feel this book does a gross disservice to the dignity of both people and devils and any suggestion that we are such simple creatures is, we're sure, odious to us both. This account is so full of lies and exaggerations, it insults even the definition of fiction, such that even we cannot applaud its cynicism, melancholy and spite. When this author can learn to draw characters that have any depth or distinction, we hope he'll be gracious enough to dazzle us. Until that time, he should go fuck himself, as is fitting.

We would also like to warn more pointedly that any loss of service opportunities that results from the ham-fisted defamations in this book will be prosecuted to the fullest extent possible, including, but not limited to, loss of new prospects and defections of current clients; any restoration of moral fortitude that, to any degree, interferes with program goals, program acts, natural and unnatural, or any consequences that are due; anything in this mendacious book that inspires a client to pray, for his or her own deliverance or the deliverance of others, for the repose of anyone living or dead, for any remedy outside our services, whether or not their asshole has been torn off, or against any inspiration of charity in the persons we represent; in short, we will defend all of our properties, interests and liberties against anything we find inimical to our benefit and the benefit of those we counsel, or otherwise injurious to our special relationship with humanity. We will meet the author in our home offices very soon and expect to come to a satisfying understanding at that time but it is our concern here for the readers of this abortifacient mess that makes this appeal so desperate. For your spiritual and emotional well-being, we implore you to read any other book, even the Bible, for the genuine good we expect it will do you. If for some reason you're a complete shithead and decide to read this poem in any part, you should remember that being unable to help oneself is grossly unflattering, while we strain to note that this author has no idea what he's talking about, and as such, you will assuredly come to a very grisly end by indulging even the smallest part of its Augean stupidity.

Sneeringly,
The Fiends

I am a bastard too; I love bastards: I am a bastard begot, bastard instructed, bastard in mind, bastard in valour, in every thing illegitimate. One bear will not bite another, and wherefore should one bastard? Take heed, the quarrel's most ominous to us: if the son of a whore fight for a whore, he tempts judgment. Farewell, bastard.

Troilus and Cressida, V, vii, 16-23

Wickedly delicious it
 out of a black and horrid gale
finishing fat the little bit,
 licking the bone until it's pale
 of what's scrummy in travail,
you've quite surprised me, I confess.
I'm Slumgullion. Forgive the mess.

But while you're here, why not sit
 and listen to the tale
of this bone and savor it
 out of a black and horrid gale?
 It's jovial, if somewhat stale,
but dolts, disasters, folderol,
I have found, don't get old.

When I was in the world just lollystrolling
 about the easy foolishness of suffering,
attentive, but not so much patrolling,
 fanning in my great, God-Given wings
 the attar sweet, the hopelessness of things,
I saw a man against a tree and leering
which beguiled me to take the sheep for shearing.

I know the awful shape of things to come.
 I am beyond all mercy and salvation.
I am in the painful shadow of that Kingdom
 where the Jewel Wasp stings and life goes on
 through the thirst and gnawing of damnation
and even though I was one of many men
I've no compunction now tormenting them

for I have known them all, and quite enough,
 the selfish, belligerent idiots who
go heads up their ass though overstuffed
 and guard from there a worldview
 that swells their balls until they shoot
and you get sperm accidents, murder, adultery,
addiction, vanity, the sob story.

As expected, he wasn't much of a prize:
 short, stupid, boring, a jerk-off,
common in every way that common dies
 not even worth the stamp or salvage cost
 for, clearly, he was already lost
to some other simple, pointless devil,
the imbeciles they take at Junior level.

I am so weary, as I am scourged,
 in a time when the saints are non-existent,
martyrs are for fables, faith devoid of courage,
 there is no test to mount for great achievement,
 no conquest brings the heart its black contentment.
What intrigues for the man who damns himself?
I show a pair of tits or promise wealth.

Women, of course, are something different altogether.
 I still have to provide someone hung
but I also have to promise he will love her
 with a heart ever new and overstrung
 as if she is, and will remain, as young.
A woman feels time sharply and needs to fill it.
A man feels time dully and needs to kill it.

I'm sure that all feels so very simple,
 how much trouble comes when we generalize!
I'm sure you can counter with great examples
 of some superior persons who defy
 the easy explanations life provides.
I'll be more mindful of the things I say
so neither of us are led again astray.

But with an *ooch* I'm compelled again
 to confront another fat and dickless fool
between the beauty of my horns and *Nodus Tollens,*
 to play my sorrow's *God of all Misrule,*
 for all that Life is miserable and cruel.
I hurt, famish, hate, am pestilential,
until his cry to God's inconsequential.

Look at this mess. This is how dreams go out.
 Another farting, unreflective loss
in a heap that life has shaken out
 all its worth in stubbles and in straws.
 I know in him the silence of the Cross.
How many shits like him are never missed?
I take a piss like every life is pissed.

I hate with the deepest sinkhole of contempt.
 From what wheat can I separate the chaff?
I'd rather punch him in the face than tempt,
 why not just break his stupid ass in half?
 The whole squalid thing just makes me laugh.
One doesn't need a proper devil sent
when he can fall by basic advertisements.

I first appeared to him in the beautiful form
 of a woman with unsupportable tits,
innocent, distressed, yielding and warm
 and, of course, the shithead was crumpled up by it
 and walked into a tree in his stammering exit.
I watched him cross the street and get run over
in a blood-soaked daze by a bike messenger.

I wonder sometimes if any of my sins merited
 the damnation I have had to endure,
the case load that I eternally inherited,
 how my soul became a pit of ordure;
 I was surely a victim of Force Majeure.
In the end, I was the best man I could be
and yet I saw the plains of Hell before me.

When you become a devil, they tear off your genitals,
 they crown you with them and make obeisance
then stick them up your nose fat and full,
 they kick you in the face and featly dance,
 they laugh and bite and drive you on a lance,
turn out your guts, pin you on a wall,
spinning you while peppering with balls.

All your friends stab you in the back.
 The first to envy, desperate to collect,
they'll decollate you just wear to your hat
 then reach down your gaping open neck
 to dance your legs and, utterly unsexed,
they lick you up like butter and guffaw.
A friend is someone who has an extra claw.

You'd better know just who you are.
 You'd better have strength enough,
be first whenever the violence starts,
 the one in Legion that's cancerous.
 You'd better know what each one loves,
every part of every joy,
destroy it all or be destroyed.

I guess all of that is not really true.
 Sometimes I can get so taken away.
I really didn't mean to frighten you,
 I feel so keenly a duty to portray
 the margins as frankly as I may.
Though the fat and stupid together make a roux,
something like that would never happen to you.

It's just all so hard to follow, impossibly hard.
 Give all you have to the poor and follow Me.
You need a house, a phone, internet, a car
 a basic living and a few nights out at least
 or, Lord knows, you'd starve in a week.
That's why people sadly pick and choose
from a Bible they can't reliably use.

The thing about the heart that's nice
 is that it always wants what it does
no matter the peril, cost or advice
 and when Misfortune asks why that was
 the little plaintive wish says, *Just because.*
It's why I can counsel you to beware.
You and I are blessedly self-aware.

No, none of that's reserved for you at all,
 you're smarter than all these other shits.
If you know how to leap before a fall
 you can negotiate the foulest pit,
 someone like you shouldn't fret over it.
There I was generalizing again.
You are not like the common dung of men.

Now where the Hell was I?
 O dear, what a funny little phrase—
I was telling you what happens when you die
 and you wake in a dark and terrible place
 into the hands of others and getting hazed.
It's much like life, I can say that honestly,
with its own kind of eternal certainty.

They like to re-attach your head
 upside-down, of course, in your neck hole
where *Keep your chin up* is the admonishment,
 where Up is Down they gaff you on a pole
 and deep inside they riot like a mole
to make a mess of your awful guts,
to eat a pie of mincemeat and your nuts.

After they pull your intestines through your mouth
 and make a smart, inexpensive tie
they stab a hat into your head and hold you down
 and fuck you in the ass until you cry
 so much you feel the boil in your eyes.
Dragged behind a carriage, pelted with stones,
my skin tore off and I saw my bones.

They put a lovely flower in my brain,
 I felt the fragrance, the burning shoot,
the Beauty that, depraved with pain,
 made all my longing destitute
 til my mind was the sweetest fruit
that craved, clustered and outgrew
the sweet of Hell it made me do.

I was taken to a wooden trough,
 whipped to my last breath then bound,
they pulled my teeth and my nose off,
 my cries made a soughing sound
 buried alive underground,
the dirt so heavy, the trough too short,
the hole in my face a choking snort.

In the world, the soul is worth a posh evening.
 In Hell, it's worth fifteen cents
for the pleasure of its suffering,
 the luxury of its predicament,
 and its sustaining entertainment.
True suffering is not heartless like they say:
it has one heart to break and one to make you pay.

While there are those that toil in Purgatory
 who think they're on the proper path
working its mercy of misery,
 who think that they can walk that Wrath
 that loves to cry and loves to laugh
in the end the thing's still human.
There's no way out. Think not on them.

But I can tell you it's so much worse
 in Hell for those abstemious squints,
those half righteous, half perverse,
 who would not or could not go all in
 for all their cowardice toward sin.
Whoever you are, make the decision
to follow your heart without delusion.

I found all the wisdom a man can use
 and then they unburied me.
Every virtue I've since accused,
 every sorrow, every hope, all mercy
 was in that grave with me.
I am out of the shadow of Hell's best confidence
and I, too, arose from the dead.

If you, of course, by some madness feel
 that you, by faith and works, can attain
Paradise by slithering like an eel
 on the abnegating, thorny muds of pain,
 if you can kill the dreaming in your brain
and bear the starved silence in which you pray
then I will leave you backward on your way.

But if, my love, we can work together
 in the sensible prudence best employed
I think that we can do much better
 than this stupid ass who got himself destroyed
 and with pleasure, cunning, glory thus avoid
the forests of fires, lions and bears,
the devouring gins, the horrible snares.

I see you're unsure, so allow me to resume
 this miserable bone's idiotic tale
so you can avoid the selfsame doom
 and in your sovereign pleasure much prevail,
 to be the empaler and not the empaled
as you see me, free and all about,
the very best servant to guide you out.

Hasenfürzchen, come to me,
 there is no need to be childish or afraid,
what harm is there if two hearts speak?
 There is no obligation to be paid,
 no understanding between us, no compact made,
we're just two friends walking on the way
whose souls are theirs to best or give away.

As a proper introduction, let's call this bone *William*,
 such a pompous little piddling fuck astray,
O what a confused little cock I am,
 (if you listen closely you'll hear him say.)
 Can someone help me straightaway
shove me up my ass, as with the clutter,
I'm having trouble fitting in another?

As I mentioned earlier, I first had tried
 your standard and basic-cost temptation,
the girl with big tits, ponytails and doe-eyed,
 but I wasn't aware of his farouche consternation,
 his sad refuge in aggressive masturbation,
and he ran off so fat and dumb and fast
I just stood there in my cleavage like an ass.

So I appeared to him in my natural state
 and he fell squealing to the ground and shit his pants.
—I sympathize with your losing fight with Fate,
 let's shit instead on Providence and dance!
 I promised him a world of power, joy, romance,
and after he stopped crying and had a drink
I thought that he and I were in the pink.

I next attempted wealth for his demise,
 for as I said that's usually enough,
until walking down the street one perfect night,
 to my delight, he was beaten up
 by some dim Darwinian thugs
I proudly recognized from other misdeeds
on which I previously advised. I'm glad they agreed.

They took his money and they broke his nose.
 Don't worry, I said, here's some more.
Another gang robbed his fancy clothes.
 You'll feel better when you're spending it, for sure,
 and there are so many pleasures to explore.
If money weren't falling out of my pockets, he said,
perhaps I wouldn't be so targeted!

Getting beaten up makes a man look distinguished.
 (A drip like him could never get enough.)
Think of all the leading men with faces squished,
 I assure you a girl will only fall in love
 with a man whose altogether rough.
Sure, it's all a little complicated
but a woman's an animal, too, let's not debate it.

I'm not the kind of person who beats up a woman.
 Aren't you? I didn't mean to imply it.
I'm merely suggesting *the fantasy* is common
 I'm in no way suggesting that you try it,
 the thought causes me the same disquiet.
People should know the difference between their nature
and what they will and will not do to her.

But let's not get tangled in psychology,
 it's all just an idiotic bore.
People are sad because of their stupidity
 the world is fine enough until there's more,
 there's really not much else to explore.
People like to fuck and take their drugs
and when they're dead you feed them to the bugs.

It's so upsetting but why don't we get back
 to focusing on you?
Before we get too far off track
 is there something that you would like to do?
 Romance, perhaps? A prostitute?
I happen to know a place to run you down
and put in for a proper fuck-around.

I said Romance, Love, a genuine connection,
 something deep and meaningful, a devoted bond
I can build a life around with joy and affection
 or are you not listening to me because it's beyond
 your power to effect things other than despond?
Though I can certainly give an ignoramus a toy,
I'm obliged to provide only reliable joys.

Beware Romance, my darling, and all love yearns to do.
 Where Beauty feeds, there's no hope for the handsome,
it's breaking the best hearts, so what hope's left for *you*?
 O lovers make a lot of ash and a little gum
 in the nightly fires of Love's crematorium!
Devotion's all too short when Love at last gets boring—
where life is mutable, the heart must go a-whoring.

Beware the *Limerence*, the apparition of conflagration:
 while love's hot leaves burst in red relief,
He makes the autumn cold habituation,
 the glamourous novelty is all too brief
 and love spoils to emptiness and grief,
the longing to escape to anything that's new,
and round and round it runs away from you.

You look like a fat, dickless, inside-out malamute
 so I expect you've suffered a lifetime of awful slights,
what about Revenge as a fulfilling pursuit?
 Nobody's called me an inside-out malamute before tonight.
 But they definitely called you fat and dickless, right?
Are you, or are you not, going to grant what I ask from you
or are we voiding our agreement with nothing other due?

We argued *for hours* (at least that's how it seemed)
 about what's to be delivered from whom to whom,
the woebegone values of the little things we dream,
 the illusion of reward, about tyranny and doom,
 traded fantastic insults, then finally resumed
to pull it all together in a plan that I think fits
and I gave him the cosmos of the most Romantic tits.

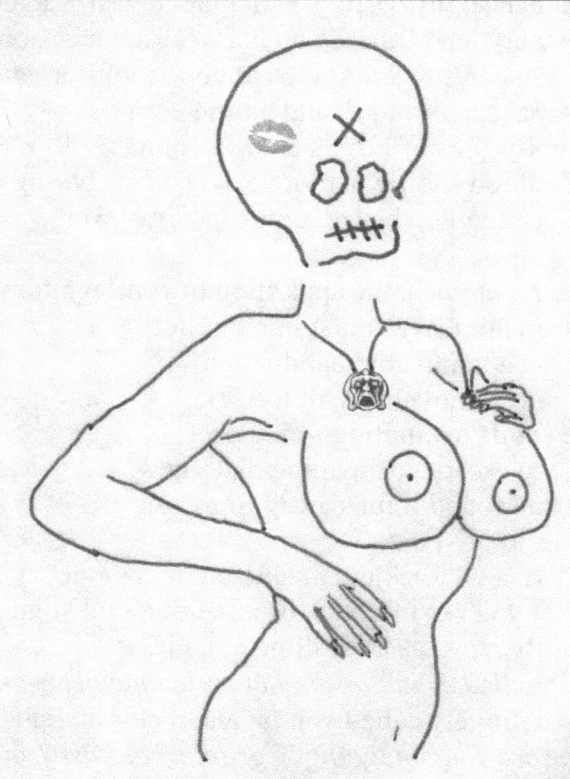

When we got to Lily Totenkopf's
 I *somehow* got him to take a whirl
on the usual snatch that gets you off
 in the sad distraction of an empty world
 with the next-blonde-up of trafficked girls.
I didn't want to watch a slob bounce on a heap,
so I vanished through a shadow and fell asleep.

This is usually where I'm stopped and criticized
 for the ugly way I always vilipend
what is best in people and overemphasize
 the cheap, the wicked, the downward trend
 just because it pays such dividends
but I rebuke your naïveté and pride
while reminding you the numbers never lie.

Don't get me wrong, I'm extremely fond
 of broken hearts and every kind of spanghew,
you inflated frogs I bounce across a pond,
 all the wickedness which you get up to
 and everything that it inflicts on you.
But if you find me especially deranged
why doesn't the general public ever change?

You have an intellect, too, or so I hear,
 and though it's quite convenient to blame me,
with all you have achieved in every sphere,
 mathematics, religion, medicine, astronomy,
 a mind uncircumscribed by any boundary
you will not confront your perverted poverty
and you will not make a just society.

And so, for that, you have me.
 So, let's get down to business:
Pleasure is a perfect theocracy.
 Feel free to wallow and confess,
 to primp your principles but keep your mess.
We all know what we would do if we could
but life wouldn't be much if we were good.

—There you are, how do you feel? She was a real looker.
 (She wasn't.) *Can we just get out of here?*
I'm well-acquainted with the smell of dead hooker,
 I just smiled a fangy smile from ear to ear
 and brushed her hair over her face with a leer.
People get so cold, so quickly and so oddly,
and I'm not just talking about the body

upon whom, amazingly, he masturbated
 but then felt so overcome with guilt
he snuck out and my wealth donated
 to have a women's shelter built
 such that my resolve did, for a moment, wilt.
I decided not to try *that* tack anymore
lest I somehow build a church or help the poor.

Hi, again. *I don't want anything to do with you anymore.*
 That seems a little unfair.
You certainly wanted me around before
 with that dirty little number back there,
 you know, the dead one, with your cum in her hair.
But let's not waste time in accusations,
there's a whole world for you of delectations.

Is there anything you'd like to pursue?
 I like poetry. O, yes, and it's delightful!
That is a noble art you should continue
 for you're so shrewd, important and insightful
 and the world these days is stupid and so frightful
we could use a genuine poet like you
to guide us to what's beautiful and true.

I really don't think there is an overarching truth.
 Isn't it appalling when people impose on you
some personal system from their vanity or youth?
 Who *dares* to say your experience isn't true?
 And people have a right to their own view.
Some people are too serious about their dung
when they are very old or very young,

I won't speculate on which condition's worse.
 In either case, it's a spatchcocked thing,
old men clinging to the rump of the perverse
 or an insufferable young hero who knows nothing.
 I'm so proud that you merely like to sing
and avoid these kinds of precious pitfalls
(at least this poem doesn't indulge in this at all).

A famous poet! We'll make you world-renowned!
 The depths are ours to sing and drive and plumb!
Just think about how often you'll be crowned!
 To start you'll need a sizeable income
 and I know just how to get you some.
No! I'm not going to be assaulted yet again!
I'm almost certainly not going to let that happen.

As he was being assaulted, I thought to myself,
 Being a poet isn't very good for the brain.
Big, gloomy thoughts wreck one's mental health,
 all those solitary hours a fatal pain,
 especially when some pointless, faggy quatrain
for all that stupidity and sorrow
is in the end all you have to show.

And what can a person *really* know anyway?
 Just because you've been alive for all of ten minutes,
fucked a few idiots, read an article, have your B.A.,
 or someone pretty praised your charm and wit
 despite neither of you having anything resembling it
is quite the trull's delusion, but what is worse
is putting that gross ignorance into verse.

While he was bleeding all over the floor
 I laid out my concerns as above:
My conscience can't support you as before,
 you are so very painfully, my love,
 too dumb to write poetry, and not dumb enough.
How reluctant I am to give you such cold counsel.
And besides, poetry doesn't sell.

Then I would like the wisdom to know the universe.
 I would not recommend *that* at all.
Wisdom given to humans has always been a curse:
 Faust ended chasing ghosts, Socrates his fall,
 even God chooses foolish things, according to St. Paul,
base things of the world, things despised,
and will destroy the wisdom of the wise.

What would you do with it, if we're honest?
 Once your empty curiosity was slaked
you would feel in life like an unwelcome guest,
 you'd be bored and pointless like a wedding cake
 served to an unrepentant rake
who is already exhausted by his bride
and fucks the maid of honor just outside.

No, you're better off being as stupid as you are.
 Be kind to yourself and enjoy the folly
that is everywhere the emptiness and dark—
 the imbecile is always free and jolly,
 the over-thinker always melancholy,
be sure it never gets him anywhere
wayward to the graveyard and despair.

I am really not seeing the benefit of this relationship.
 I wanted to rip his dick off and make a boutonniere
but I just looked at him and bit my lip.
 Apparently, I haven't been making myself clear
 about the kind of living that prospers here.
Any other attachment will make you sick and quick
like the worm in the tongue of a craving lunatic.

You shit on everything so what's my bargain?
 Because of you there's nothing to enjoy!
Happiness kicks my ass again and again,
 whatever's good crumbles as it cloys
 and every pleasure is utterly destroyed!
 If you want to kill yourself, I have a flamethrower.
Of course, you do. Would you prefer something slower?

I would prefer you fuck yourself and die,
 is that part of the service you provide?
I feel like you're upset. May I ask why?
 You helpfully suggested I commit suicide
 by burning myself alive!
I was being flip, you were becoming hysterical.
You ruin every meaningful thing in the world.

You mistake me, Sir, if you despair as such
 or think that I have such a miserable view.
Rather, I love this muscular world *too* much,
 its bracing contests are its greatest virtue
 and all my greatest flights I find in you.
We are not served, it's true, by more than all;
for every heart the thrill is in the fall.

There is nothing then that you can give me.
 What exactly do you want to be given?
The universe is silent, dark and empty.
 I can give you all that you imagine
 and without the need to be forgiven.
Let's not discover what you love to do
long after you find the book is killing you.

Why the Hell did I follow you? I should have known
 if you exist, then God does, too.
True wisdom knows that you are on your own.
 Whether or not your logic is true,
 Proud beast, does God exist for *you*?
Do you think He has nothing better to do
than slave one minute of His Sovereign life for you?

What do you envision when you think of a King?
 What do you expect of a Lord?
A master with whom you're on equal footing
 who allows you permission and accord,
 liberal in love, license and reward,
putting away His power to serve yours alone,
cherishing your freedom above His own?

That sounds suspiciously like Pride.
 Ah, the little center of the universe
tucked away in a corner of the Night
 whose Vanity and Temerity is so perverse
 they get up on their hind legs to reverse
the Order and the Rule of a Lordly House
stomping through the sugar like a mouse.

It isn't proud to think that God is kind,
 that He knows my name and is patient
for He knows the name and number of all mankind,
 all their weaknesses, and their predicament.
 That's a neat trick and a lovely sentiment
but I know every name in the phone book
and none of them are worth a second look.

It's always the same damn thing with you people.
 How self-centered are you malcontents
who think God has time to attend eight billion imbeciles
 and their love, money, luck, laments,
 the outcomes of their sporting events.
When I was a man, I had sense in my head
and was never so hopelessly misled,

because, sure, that's what I'd do if I were in Paradise,
 instead of all of the luxuries partaking,
I'd fret over the demands of a bunch of body lice
 who are needy, ungrateful and always forsaking
 commonsense for grief of their own making.
While God and his Angels are humping themselves fun,
I can be your more personal one

for the heart can only hope on its pleasures
 despite our virtue or our vice,
too short the moment, too small to measure
 the love, the beauty and the price
 which disappear as they suffice.
Though no one can give you any more than this,
I can lengthen the wisp as it vanishes.

The end is dreadful but the best of them declare,
 and I want for you, in part, to say the same,
I see the Beauty of life everywhere
 and I know the power of it by my name.
 At that terrible majesty there is no flame
can burn your flesh or ever melt your heart
that likes it pretty but loves it truly dark.

That's enlightening but I think I'll go.
 That's fine but as you're halfway in
you'll have to pay up now what you owe
 for all that you've entwined yourself to sin,
 that poor dead darling you did in.
The way back is terrible, painful, destructive sorrow,
it's inhuman and a terrible death to go.

Repentance is our salvation that you have lost.
 I see. And you think it has no other demands?
A simple admission without any other costs?
 How blind and full of shit are the damned.
 As I said, you'll crawl a Nightmare Land
where I'm very sure you're not strong enough
to give to death what you owe to love.

It's a fat mistake to think that you can save yourself,
 to think there's anything that you can do
that will not lead you back to Hell.
 The only way left to you
 is to keep on going through,
refine your gifts, and build for war,
be strong, ruthless, cold and born.

I can either suffer the pain of damnation
 or suffer the pain of contrition when I repent
and by the latter earn my salvation
 through hard humility and all torment
 to my field, my rest, my peace, my tent.
Your arguments are the sad and small
envies of one who's lost it all.

Sad and small indeed they are
 but with well-wishes for your Grace
from someone who knows both dark and far
 how this ends and in what place
 though I'll be with you, just in case,
your resolve and your wherewithal
is just as big as sad and small.

The first ditch is shallow, the first hill a hump,
 the first heart brave as gold and faith has a voice,
next we'll have to run a little, the gap will need a jump,
 but then infested mires we will have to make a choice
 in the silence and exhaustion that summarily destroys
the gold, the faith, the hump, the ditch, their sensuality
all start as a simple wish and lead straight back to me.

Consider the moral of the book of Job
 and the suffering of the man, at least.
He was the most humble, righteous man on the globe
 but learned God's dominion and caprice
 to be loving, whimsical or a beast.
The point is, your works or contrition have no bearing
on the Sovereign heart, despite your forswearing.

I just wonder in what demented imagination and Pride
 you think you're owed a favorable judgment,
even after you've done all that was prescribed
 if He should damn you to everlasting torment
 because He hates your fat face. Who are *you* to dissent?
How much worse will be the agonized regret
when you didn't get all that you could get?

So if I understand your idiotic premise,
 because God is our Sovereign King,
and is ungovernable by a group of wretches,
 He's a savage madman who's so unfeeling,
 I should just go around fucking everything.
Because God and I both can choose, I should assume
the Lord is cold and brutal and I'm doomed.

I am merely asking you to consider your position.
 What kind of world is so inimically designed
the man suffers by its every opposition
 to the loves, the dreams, the joy he starves to find?
 What compassion made it? And what mind?
To whomever's service you choose to submit
the joy will always ask if it was worth it.

And you believe your fleeting pleasures are?
 No feeling state of mind is everlasting.
Accepting that transience is best by far
 to truly feel joy beyond all surpassing,
 to make your peace with everything that's passing.
Nothing will sustain you as you think it will.
Consider those in Paradise who shrivel.

For I tell you, if you misunderstand yourself
 and believe Heaven is where your desires are,
knowing Good and Evil, you'll find it Hell
 and feel its promise eating in your heart,
 the fruit go poison, and your love go dark.
The splendor will remind you of the sinks
every time you love and wish and think.

Whether or not you proceed or defer
 I insist I have, as is right and proper,
presented the argument with full disclosure.
 If I suggest that you have sex with poppers,
 fuck a boy's face or featly top her,
you only have your freedom to accuse
if you can't choose what you love to choose.

Does anyone ever believe this ridiculous story?
 No, Hell has only six people in it from Chicago.
Thanks, smart ass, why don't we do an inventory
 of all the wonderful gifts you have bestowed
 to inspire me to continue on this road?
I've been robbed, stripped of all my clothes,
practically gang-raped til comatose

then, betraying my last trace of dignity,
 you led me to prostitution and its sleaze
where a girl died right underneath me,
 is there anything else to add to these?
 Yes, you now have venereal disease,
I was going to tell you before but you already had a lot
on your plate, and in all the tantrums, I forgot.

You idiot! You fucking bastard! For God's sakes!
 I'm as upset as you are but the main thing here
is not to blame yourself for your mistakes,
 I'm almost certain it's not a super-gonorrhea
 and the CDC may have a few ideas.
I'm not blaming me, I'm blaming you!
Well, that seems like a cock-eyed thing to do,

I'm not the one with the gross discharge.
 I think this would also be the appropriate place
to remind you that some small setbacks *seem* large
 when considering things like agony and disgrace,
 though this particular fiasco is a fucked-up case
that is enormous, unforgivable and fatally virulent
so just ignore everything I just said.

You stupid ass! That's it, I'm leaving! I've had it!
 I wouldn't go that way if I were you.
Why the Hell not? It's the police. *O my God! Holy shit!*
* You asshole! Now what the Hell am I going to do?*
 Go to jail, get hate-fucked every day and a face tattoo
that reads, *Blow Job Machine, Insert Penis Here*
and generally live in sorrow, agony and fear.

This is all your fault! You have to get me out of this!
 Now all of the sudden you want to be best friends,
well, you can go and take a flying piss,
 as far as I'm concerned, this partnership's at an end
 and the next time someone tries to help, I'd recommend
you show a little gratitude, you idiotic tit,
and maybe in the end you'll get the best of it.

He begged me to help but my mind was made up
 and he was sentenced to jail for fifteen years
where he was beaten every day and fucked up
 every conceivable hole (even his ears)
 til right before a prison conversion, I appeared,
and worked a barrister I knew that got him out
on the condition that he be more pliant and devout.

Of course, instead of re-investing in the program,
 he fought me every step of the fucking way.
I assured him there was no bigger asshole than I am
 when one reneges on promises to pay
 when a priest approached us, old and gray,
who insisted that, through the blood of the Lamb,
he was redeemed from the fire of the damned.

I was admittedly unpleasant at his defection.
 I squashed that reverend's head just like a peach.
I suggested that any priest he chooses for his protection
 not be fucking children, or at the very least,
 believe the Creed, and practice what he preached.
There's no better way to make a moral plain
than standing in a person's blood and brains.

So we fucked off all kinds of lovely slices,
 taking all the pleasures that our cracks could get,
fucking girls and boys of all latitudes and sizes,
 going ass to mouth with lovely leverets,
 all their baggy tits and tubby faces wet,
breaking night and day into every kind of house,
romping down the walls with my sweet *Knuddelmaus*.

We flew from land to land, laid every town to waste,
 transported in a moment to beds both near and far,
licked in like siroccos to take a scorching taste,
 we met them hard, and we brawled, in every roadside bar,
 in every park and parlor, forum and bazaar,
til someone's pregnant, someone's dead, and we have to go
mice in the midnight cupboard and through another hole!

Magic and deception and the scrapes of derring-do,
 like when confronted by the Helots Biker Gang,
I opened all the cages at an agitated zoo,
 then lions, hippos, voles and slut orangutans
 nibbled off their genitals and all the horror sang.
We ploughed their dainty asses in a glorious melee
then off on our Chimeras we had rode away.

We parked our ten-headed beast outside Tubb's saloon,
 and he gobbled more than half the town alive;
then there was the orgy during the last two weeks of June
 when we wagered all the assholes at a local dive
 a magic tap of ale against the pleasure of their wives;
the town of Friend died frozen in the nude
when every hypocrite was holy and was rude.

Each evening had to end, as part of my ambit,
 if not with lifelong injury or spiritual hurt,
then mischief at least, like a raucous coughing fit
 during the *gustoso* of a soft cello concert,
 an outrageous fart that makes an awful squirt
in her shimmering white moonlight outfit,
then the blackout, the fall down the stairs, the vomit,

and as her effeminate architect tries to console her,
 I like to replay the scene and bust his balls
for there's nothing like the rich, capacious timbre
 of the crying in a bathroom stall.
 Yes, it's seamy, I was human after all,
but for all the human misery lustrous Hell enjoys
be sure it was a human that invented *Schadenfreude*.

What's deserved, what's proper, what's disgusting,
 well, we can debate how far we like it cruel
but when stupid burns itself with blubbering combusting
 how I savor and the sizzle always makes me drool!
 I'll behave if it happens to one other than a fool,
should I chance to meet such a hero, of course,
and throw him out a window with a scruple of remorse.

But I will always love the world's foolish repertoire,
 those drowned in a cesspool, dunk tank or grease trap,
those who "forget" an infant in a sweltering car,
 the preening writer of some best-selling piece of crap
 who chokes to death like an heiress on his Sheaffer cap
which the editor assured the Board was fine,
the ghost writers will finish it on time.

When six in the morning, at last he went to bed
 I displayed the bodies and framed some twat,
rebounding all our crimes upon his head,
 then new maggots of trouble I begot
 to stir the morning's coffee, dark and hot,
and sat by the window as he slept
listening to the simple world that wept:

Poorer is the midnight of Berlin.
 In Versailles, the boils black exude.
We did Morocco sharp to do her in,
 we like our English sad and thick and lewd,
 and in Bern assholes were our food,
though we can't claim any part of Québec,
where every hole was already wrecked.

The nights in Africa were five a bed,
 we danced in richest colors, sang in hot delight,
and when we left, the cattle all were dead,
 the flies darkened the April days to Night
 and vultures on the rooftops did alight.
The feast became the sand of famine,
gnawing on the hunger, heat and wind.

We ran the sultry ravage through the East
 where the blossom all unfolded fragrant joys,
we rooted up the flowers like a beast,
 browsed every dirty parlor of its toys,
 unpetaled all the girls and ladyboys
pawing the gawping tourists and perverts
wriggling in the neon and the dirt.

And then, of course, there was, alas, Des Moines
 (lest you think we forgot the dumb and poor)
where Hell itself has no such stinking loins,
 we met the whole town's charm behind a drugstore
 and pushed the stink at both ends of a whore.
Is there on earth any sadder, more droopy rump
than this drabby shithole and fat cum dump?

And it was here where it all began to unravel,
 (when I think back now, I almost want to fart.)
We paid the slag forty and wished her well
 but then I got the mischief in my heart
 and, disporting with the lesser Black Arts,
I made a pocketful of mice from forty dollars
who each wore a mirror on a collar.

They squeaked, she screamed, it alerted the police
 who happened to be, as Fate will sometimes do,
out in force on that particular street
 where a friendly bar hands out a beer or two
 to our courageous officers in blue
which is, of course, against all protocol
but living doesn't bother Hell at all.

I suggested that he slap her in the head
 once or twice to get her to calm down
and in his zeal her skull came off instead
 grinning at his feet and rolling around,
 blinking with an awful huffing sound.
I looked at him like the fucking spaz he was
and gave him a dark moment of applause.

Well, I guess we're now two boys on the lam,
 though I suppose that isn't really true
for I'm all right but you are clearly damned
 and well, if I'm honest, between the two
 they're not looking for me, just for you.
You fucking idiot, you have to get me out of here!
Can't you again just make us disappear?

I can do all sorts of wonderful things
 but quite frankly, I don't appreciate your tone.
When you slap some bitch's head off and hurt my feelings
 I kind of feel like you are on your own,
 Ingratitude is not something I condone.
Hurry up, for God's sakes, they're closing in on us!
And as he ran, I heard the music of a Circus.

I couldn't a better stratagem devise
 to effect such a merry getaway,
no better place to pick up a disguise
 and also get ourselves a fuck in play
 with some desperate carny runaway.
Where animals and men keep company
it's good to have a devil in the fleas!

We slipped under a tent and blended in,
 pulling ropes, watering animals, carrying props,
slithering about the action and the din,
 vermiculating underneath the Big Top
 while the place was crawling with the cops.
Creepingly, we made our way around
to the trailer of Rossimo the Clown.

If we were going to escape this hot morass
 it was clear that the clown would have to go.
Trying to shove a clown up his own ass
 takes a lot of doing— we managed it though,
 and *that's* the jolly end of Rossimo.
I am not sure if a clown has a soul
but I can certainly vouch for a clown's asshole.

In big shoes, white makeup and a painted frown,
 we bantered with the cops, strolling in plain sight,
and with the wide province of a clown,
 we sniffed at every tail like an antic parasite
 who knows how to suck at life all its sweet delight.
It seemed we would frolic out of trouble again
til there fell the shadow of a mound of loving woman.

Busy Bustums turned on us, the *loveliest* delight,
 the most fantastic, toothsome SSBBW,
who wiggles standing still, though rarely upright,
 who lifts her soft belly to help us find her flue,
 who never met a condom she would do—
why, if you want a blowjob mammoth and uncovered,
you can forget every other lover

and even though we were being chased,
 when she winked and pushed her great big tits together,
the slough within her eyes to take a taste,
 he climbed on her like a frog on a bellwether
 and fingered through her wet and sultry heather,
vanishing in that soft and fleshy wallow
then, reverse cowgirl, he was swallowed.

Among the tumblers, pipers, cops and beasts,
 the trapeze artists flying overhead,
in the music, shout and shit they had their feast,
 in the sunshine and the dirt they made their bed
 and then the climax popped off its own head:
a delicious scream, a frantic Judy found
the devouring asshole of Rossimo the Clown.

In the horror, tumult and the panicking,
 in all the accusations going around,
with all their sins to be exposed under questioning,
 well, no one could remember the new clown
 being of the party before this town.
It was at that moment, he came limping on the scene
rubbing his balls, roughed as with shagreen.

They punched him in his red rubber nose,
 threw him to the ground and stomped his head,
they seized him but he wriggled from his clothes,
 he begged me for help as he was buffeted,
 clouted worse each time that he had pled.
Hemorrhaging and drivelling in the shit and straw,
fucked by roustabouts, acrobats and dogs

in revels of anger, misery and clamour,
 it was finally time to pull him from the fray
but just as I was about to cast a Glamour
 I heard a dim and lovelorn carny pray
 such that the twinkle made me turn away
for the opportunity to soothe and inquire
if I might be better to serve desire

and, forsaken, he found reserves of ferocity
 that gave him the fighting strength of ten
by which he fled from them (he's yet to thank me)
 into the staging area where some men
 were moving all the animals from their pens
and in all the confusion, trampling and the fright
he was devoured to the last delicious bite

which is, of course, the mess you met me with
 I was licking clean of the last morsel,
the woe-beset pity of his death,
 the glory of his procession into Hell.
 I'm quite sentimental, as you can tell,
I carry his pluck and bones wherever I go
to remind me of the defiance and the gusto.

As for you, there's no need to pull away.
 Though these were *his* particular facts
and a little dreadful in parts, you cannot say
 it wasn't a rich life of towering acts,
 an affirming joy with each climax.
And you would do better to be my friend
then endure only my torments to the end.

If you listen, I guess, Life will tell you how
 to find meaning in this world, if just a snatch,
while its heights are vanishing, even now,
 though I can better help you keep your catch
 for you and I are quite the perfect match
for the full expression of a most human tableau
in the most familiar Heaven that we know.

What deadens life chides you to be wary
 of some semblance of reward that pales by me.
Will you be cold and false an adversary
 or find yourself in my company?
 Will you make a living pact with me,
dream with my power, pelf and counsel
to gain and gainstand all the best of Hell?

I may be bankrupt of feeling and care
 but I loved deeply in a fate with so much less.
I am not its agent of madness and despair,
 I walk with you to the end with mortal seriousness:
 my comedy is nothing more than anaesthesia awareness,
I assure you I am screaming in my head
and it's in this jest the heart has profited.

The worth of Life begs for one guarantee,
 knowing the vanity of it all, of course,
and that's the illumination of the Free.
 We only truly blossom when, without remorse,
 we return Life to the dust with our own force.
No one that had the capacity to forgive
would blame the truly free because he lived.

No one needs to learn how to laugh or dream or cry
 but how you sharpen these is how you make a Paradise
without a fatal Tree, without ignorance or with lies.
 With every dream the heart fructifies with vice
 for which you are the Tree of Death and I the Tree of Life.
How many must Hell accept, how many must God condemn
before Beauty and Grief sing their fulgent requiem?

[*Help me, please!*] What's that? Why, Mr. Bone!
 It's unjust to upset our guest so selfishly
[*It burns!*] I think you could use a little time alone.
 [*No! Please help! Somebody please help me!*]
 Your help has never left you... but, O dear me!
Look at this *unfortunate* dog! Have you had nothing to eat?
Here's something to gnash on, darling, who's very sweet.

I love animals. Now, whatever your particular destination,
 what pleases you best, I hope you can put aside
his chance misfortune and hysterical demonstrations,
 the choice is yours, of course, however you decide
 but would you mind if I just walked alongside
not as anything other than an interesting friend
since, no matter the way, we'll end at the same end?

If all alone you find yourself in such a terrible stew,
 when Life's a bleeding headwound, Love a dead disaster,
you're at your last and you don't know whatever just to do,
 as dying's hot, & Life is sad, & twixt the two is laughter,
 when that beast is at your bones and you would be its master,
when your worm awakes famished & your dead rise up as one,
you find yourself a devil, too, like this Slumgullion!

www.ingramcontent.com/pod-product-compliance
Lightning Source LLC
Chambersburg PA
CBHW070131240526
45468CB00002BA/1008